GLI ACCENDINI

Stefano Bisconcini

CHRONICLE BOOKS

SAN FRANCISCO

First published in the United States of America by Chronicle Books in 1997.
Copyright © 1991 by BE-MA Editrice.
All rights reserved. No part of this book may be reproduced in any form
without written permission from Chronicle Books.

Printed in Hong Kong.

Library of Congress Cataloging-in-Publication Data:
Bisconcini, Stefano.
 Lighters = Gli Accendini/ Stefano Bisconcini
 p. cm — (Bella cosa)
ISBN 0-8118-1869-1 (pbk.)
I. Cigar lighters–History. I. Biconcini, Stefano. Gli accendini.
II. Title. III. Series.
TS2280.B57 1997
688'.4'—dc21 96-52101
 CIP

Photography: Stefano Bisconcini
Series design: Dana Shields, CKS Partners, Inc.
Design/Production: Robin Whiteside

Distributed in Canada by Raincoast Books
8680 Cambie Street
Vancouver, B.C. V6P 6M9

10 9 8 7 6 5 4 3 2 1

Chronicle Books
85 Second Street
San Francisco, California 94105

Web Site: www.chronbooks.com

Introduction

Fire has always been a companion for humankind: it heralded the dawn of civilization and has been a fundamental element of man's most important achievements. For many centuries, the fire-steel was the device most commonly used to produce fire, but the invention of the flint permitted the construction of the first modern lighters in the early years of this century. The lighter created a new, easy, clean, and safe way of generating a flame.

The evolution of this small object reflects the technological progress of the twentieth century. Today, it is an industrially manufactured device, used in a variety of ways, and so common that it is made in disposable versions. However, fine quality lighters of handsome design are still produced, just as in the past, from precious materials.

Reviewing its history, we shall see that the lighter reflects the character of a century of our lives.

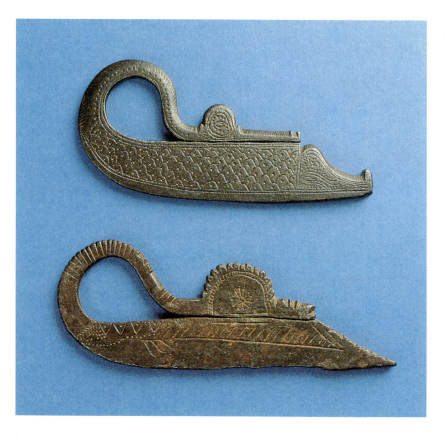

Nineteenth-century oriental fire-steels. Probably manufactured in India.

Acciarini orientali del XIX secolo. Probabilmente di provenienza indiana.

France

\mathcal{E}lectric potassium bichromate table lighter. Glass and chromium-plate; c. 1880.

Francia
Accendino da tavolo elettrico al bicromato di potassio. Vetro e metallo cromato; c. 1800.

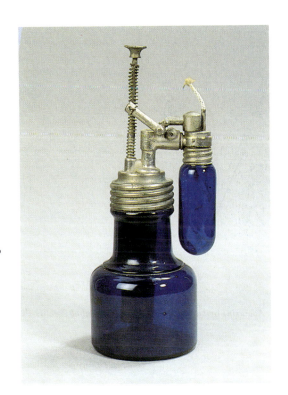

Austria

Curious lighter with mercury fulminate paper and saltpeter wick. It is paired with a theatre lamp that is lit in the same way. Chromium-plated brass; c. 1885.

Austria

Curioso accendino a esca funzionante con fulminato di mercurio. È accoppiato ad una lampada da teatro che viene accesa nello stesso modo. Ottone cromato; c. 1885.
➤

France

Chromium-plated brass pocket lighter that produces sparks by friction with emery. The wick is lit by rotating the wheel at the side; c. 1890.

Francia

Accendino da tasca in ottone cromato che produce scintille mediante sfregamento di uno smeriglio. L'esca viene accesa ruotando l'anello laterale; c. 1890.

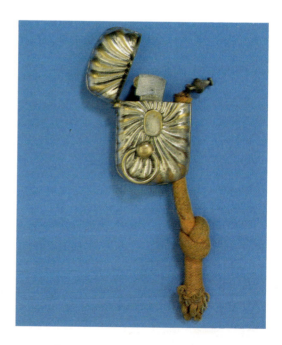

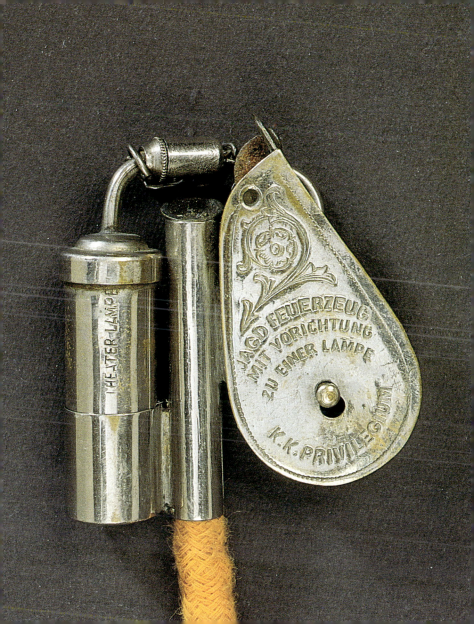

Germany

Pocket lighter with a wick lit using the mercury fulminate system. The wheel on the opposite side is rotated, and the hammer strikes the strip of impregnated paper, producing sparks. Chromium-plated brass; c. 1900.

Germania

Accendino da tasca ad esca funzionante con fulminato di mercurio. Si ruota l'anello esistente nel lato opposto e il martelletto percuote la striscia di carta impregnata provocando le scintille. Ottone cromato; c. 1900.

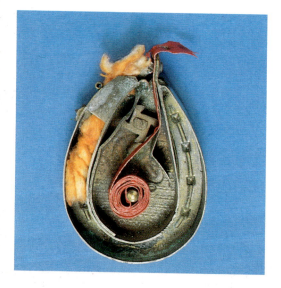

Interior detail.
Particolare interno.

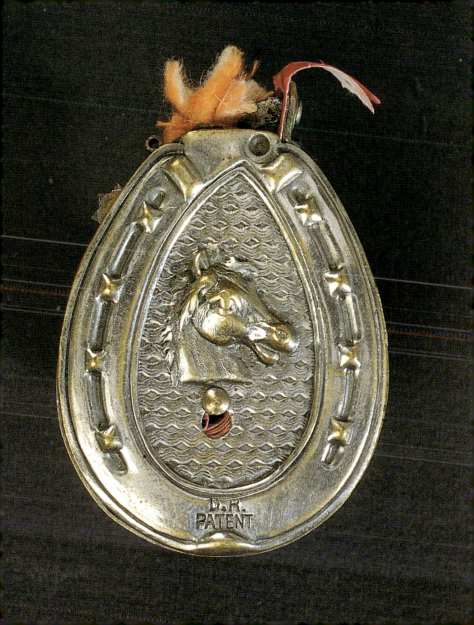

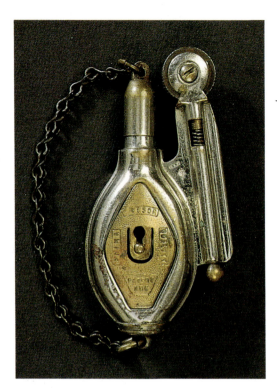

Austria
Tresor model
A brass pocket lighter. Under the plate on the front marked "Prima Quality—Patent Ang." there is a housing for two spare flints; c. 1908.

Austria—modello Tresor
Accendino da tasca in ottone. Sotto la placchetta anteriore marcata "Prima Quality—Patent Ang." si trova un alloggiamento per due pietrine di riserva; c. 1908.

Austria
R.K.

Pocket lighter in chromium-plated brass, with wick. The flint was used just for lighting the wick; c. 1910.

Austria—R.K.
Accendino da tasca e miccia, in ottone cromato. La pietrina serve solamente per incendiare l'esca; c. 1910.

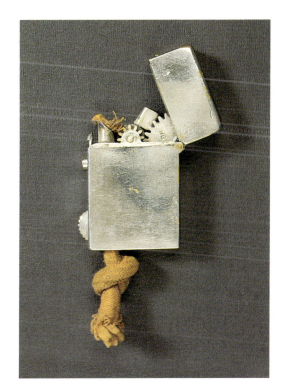

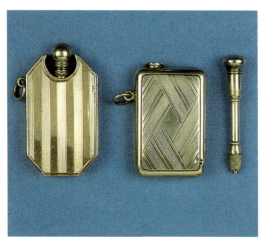

France

*L*ate nineteenth-century matchholder made in brass, in the shape of a boot and kitten. It was modified to create a lighter with the addition of the flint-holder and wheel of a Flamidor dating from about 1912.

Francia

Portafiammiferi fine '800 in ottone a forma di stivale con gattino. È stato modificato artigianalmente in accendino utilizzando lo spingi-pietrina e la rotella Flamidor del 1912.

*T*wo friction lighters in silver. They consist of two pieces: the body, and a steel-pointed rod; c. 1910.

Due accendini a sfregamento, in argento. Si compongono di due pezzi: corpo e astina con punta dùacciaio; c. 1910.

Austria
R. K., Caligula model

*C*hromium-plated brass pocket lighter in the shape of a lady's boot. R.K. are possibly the initials of Richard Kohn; c. 1912.

Austria—R. K.—modello Caligula

Accendino da tasca in ottone cromato a forma di stivaletto da donna. R.K. postrebbe essere le iniziali di Richard Kohn; c. 1912.

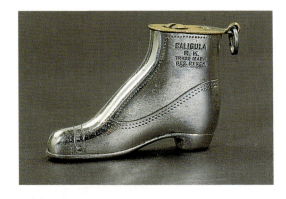

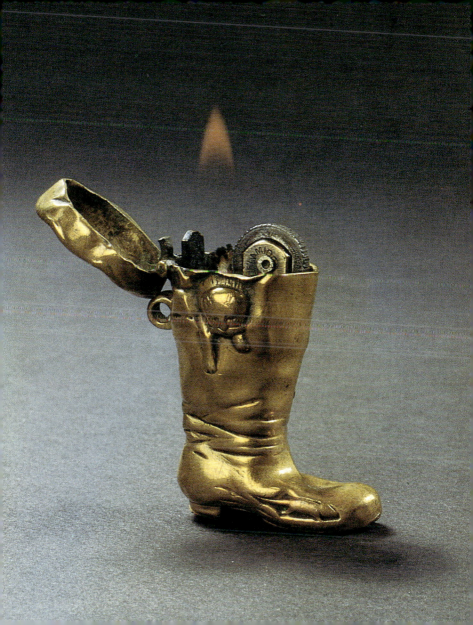

USA
The Capitol Lighter

A table model made in brass. It is marked "Patented 17 September 1912" The circular base into which it was inserted is missing. Note the complex system of levers; c. 1913.

USA—Capitol Lighter
Accendino da Tavolo in ottone. È marcato "Patented 17 September 1912." Manca la base circolare nella quale è inserito. Notare il complesso sistema di leveraggi; c. 1913.

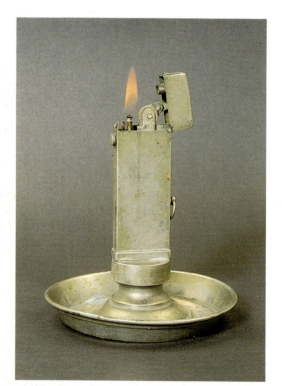

Germany

Brass table lighter in the form of a candlestick holder. It is operated by pressing the button; c. 1913.

Germania
Accendino da tavolo a forma di portacandela, in ottone. Funziona premendo il pulsante; c. 1913.

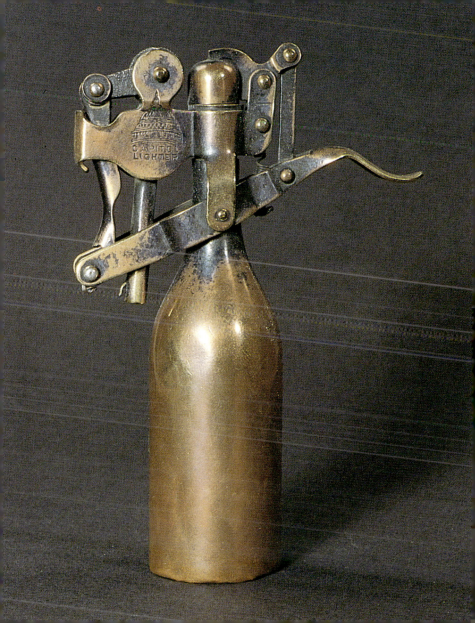

Austria
R. K.
Chromium-plated brass pocket lighter with a beautiful engraving of a stag; 1914.

Austria—R. K.
Accendino da tasca in ottone cromato con una bella incisione di un cervo; c. 1914.

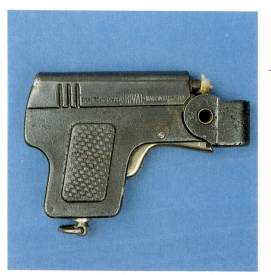

Austria
R. L., The Rival model
A pistol-shaped pocket lighter in burnished metal; c. 1913.

Austria—R. L.—modello Rival
Accendino da tasca, in metallo brunito, a forma di pistola; c. 1913.

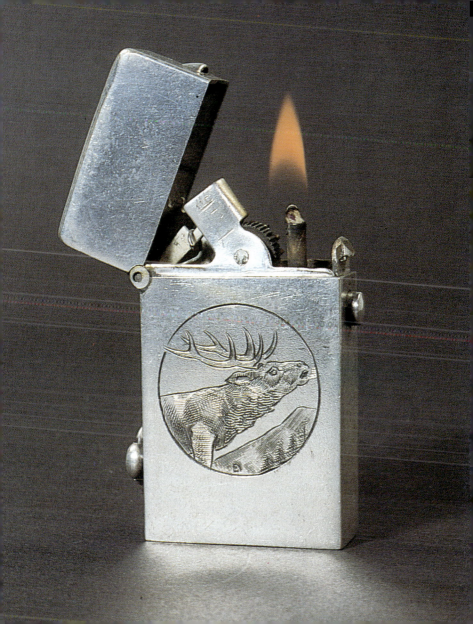

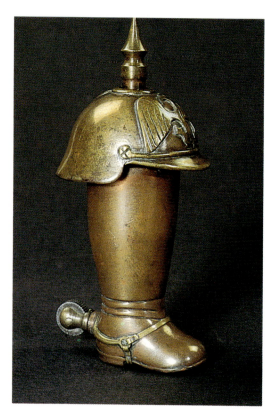

France

Handcrafted lighter dating to World War I, made in copper and brass and shaped like a boot with a German helmet. The tip is drawn out towards the wheel to catch the sparks; c. 1918.

Francia
Accendino artigianale della I guerra mondiale in rame e ottone. Raffigura uno stivale con elmetto tedesco. La punta si sfila e viene avvicinata alla rotella per ricevere le scintille; c. 1918.

France

Medal-shaped lighter in brass, with the French cock, dedicated to the defense of Verdun; c. 1918.

Francia
Accendino a forma di medaglia con la figura del gallo francese, in ottone. È dedicato alla difesa di Verdun; c. 1918.

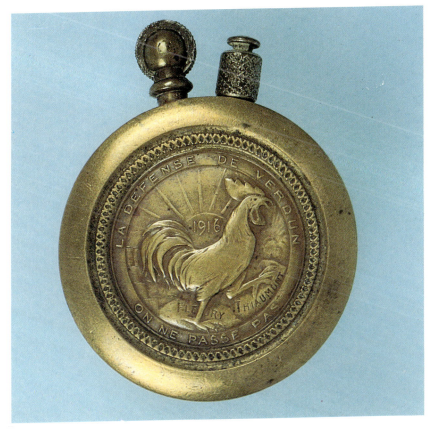

France

Handcrafted lighter in the shape of a book, with delicate floral engravings. In brass and copper; c. 1918.

Francia
Accendino artigianale a forma di libro con delicate incisioni floreali. In ottone e rame; c. 1918.

➤

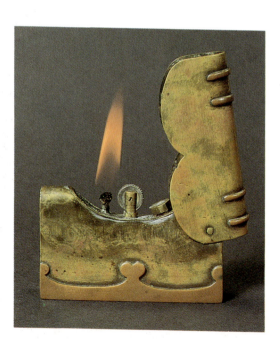

France

Handcrafted World War I lighter in copper and brass, made in the shape of a book; c. 1918.

Francia
Accendino artigianale della I guerra mondiale in rame e ottone, ha forma di libro; c. 1918.

◄

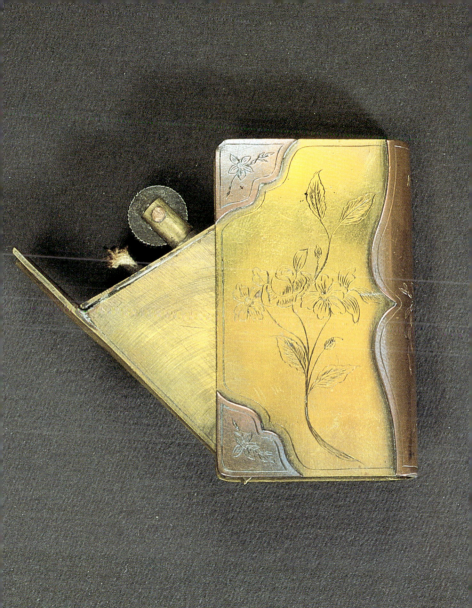

France

Hand-crafted World War I lighter in brass and copper, shaped like a book. 1918.

Francia
Accendino artigianale della I guerra mondiale, in ottone e rame, a forma di libro; c. 1918.

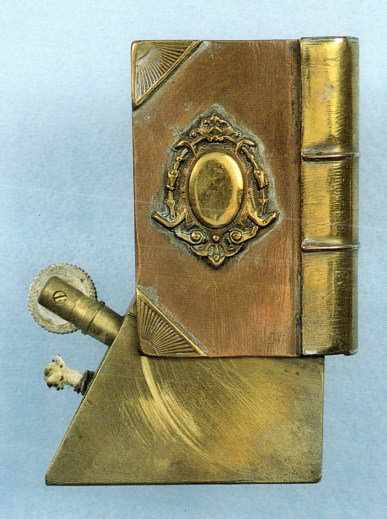

France

Handcrafted table lighter representing an old muzzle-loading cannon on a wooden carriage. Nicely made in brass and copper, its mechanism is contained in the breech; c. 1918.

Francia

Accendino da tavolo, artigianale, che riproduce un vecchio cannone ad avancarica su affusto in legno. Ben realizzato in ottone e rame, contiene il meccanismo nella culatta; c. 1918.

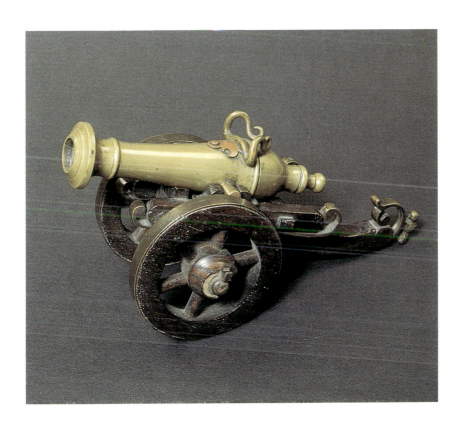

France

Pocket lighter in the shape of an airship. Made in chromium-plated brass and copper, it bears a metal plate confirming the payment of the tax on matches and lighters; c. 1919.

Francia
Accendino da tasca a forma di dirigible. In ottone cromato e rame, reca la placchetta metallica comprovante il pagamento della tassa sugli apparecchi d'accensione; c. 1919.

Medal-shaped brass lighter dedicated to the English-speaking allies participating in World War I; c. 1918.

Accendino a forma di medaglia dedicato agli alleati anglofoni per il loro contributo nella I guerra mondiale. In ottone; c. 1918.
➤

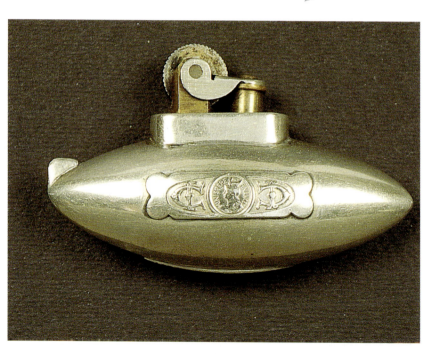

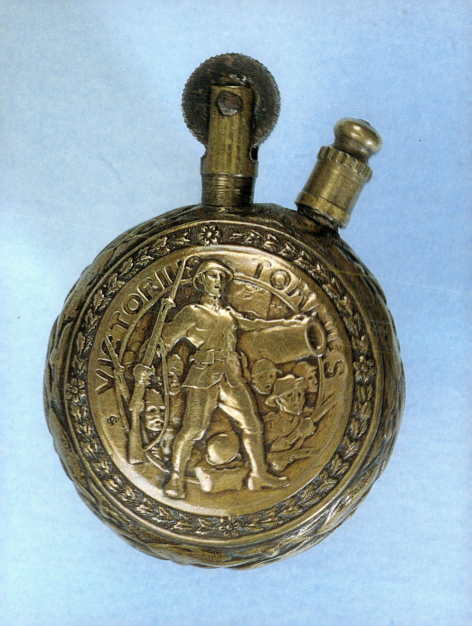

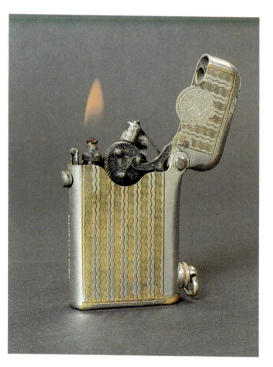

Switzerland
Thorens, Standard Original model

Pocket lighter made in brass plated with chromium and gold; c. 1919.

Svizzera—Thorens—modello Standard Original
Accendino da tasca in ottone cromato e dorato; c. 1919.

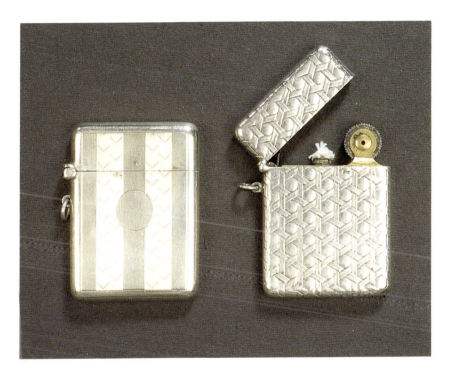

France
Flamidor, Briquet Parisien model

Pocket lighter made of brass, with a housing at the side for two flints and silver sheath; c. 1919.

Francia—Flamidor—modello Briquet Parisien
Accendino da tasca in ottone con riserva laterale per due pietrine. La guaina è in argento; c. 1919.

Italy

\mathcal{A} pocket lighter advertising the Nuova Ansaldo company. Chromium-plated brass and enamel, with the emblem of the well-known Genoese industrial concern. A few score of examples were made; c. 1922.

Italia
Accendino da tasca pubblicitario della Nuova Ansaldo. Ottone cromato e smalto con l'emblema della nota industria genovese. Ne sono stati costruiti alcune decine di esemplari; c. 1922.

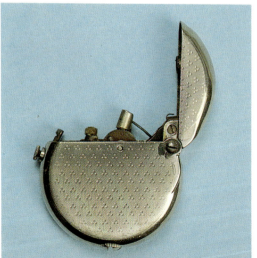

Switzerland
Thorens

\mathcal{W}omen's pocket model in chromium-plated brass, with a circular shape; c. 1926.

Svizzera—Thorens
Modello circolare per la clientela femminile, da tasca, in ottone cromato; c. 1926.

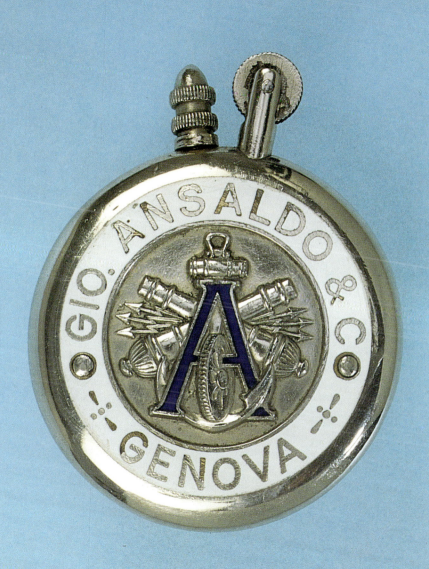

Great Britain
Dunhill, Unique B model
Pocket lighter in silver-plated brass, covered in polished shagreen, or sharkskin; c. 1924.

Gran Bretagna—Dunhill—modello Unique B
Accendino da tasca in ottone argentato e ricoperto con pelle di pescecane levigata; c. 1924.
➤

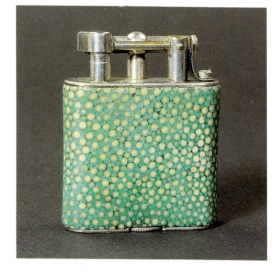

Germany
Tschupp
Pocket lighter in silver-plated brass and enamel. 1925.

Germania—Tschupp
Accendino da tasca in ottone argentato e smalto; c. 1925.
➤

Pocket lighter in chromium-plated brass with silver band; c. 1925.

Accendino da tasca in ottone cromato con banda d'argento; c. 1925.
➤

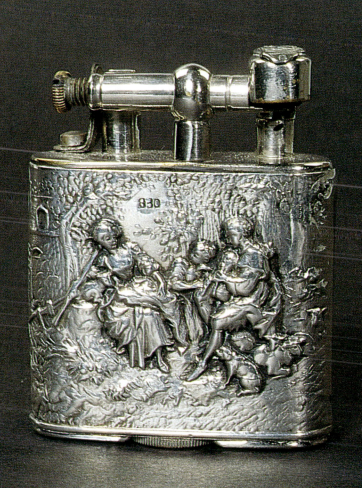

USA
Ronson, Art Metal Work Inc., The Banjo model

A table lighter in silver-plated brass and snakeskin; c. 1926. A pocket version was also made, a replica of which was issued in 1986.

USA—Ronson—Art Metal Work Inc.—modello Banjo
Accendino da tavolo in ottone argentato e pelle di serpente; c. 1926. Esiste anche la versione da tasca della quale è stata fatta una replica nel 1986.

➤

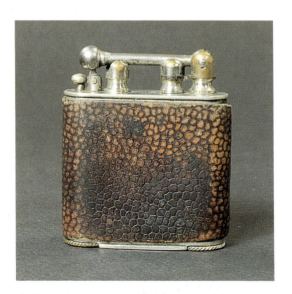

USA
Douglass

Pocket lighter in brass and leather, made in Chicago; c. 1926

USA—Douglass
Accendino da tasca in ottone e pelle, fabbricato a Chicago, c. 1926.

◄

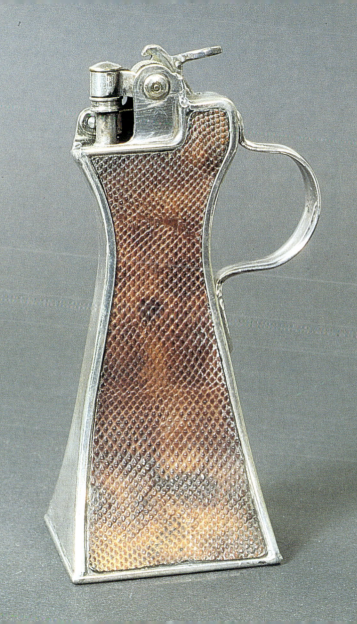

Switzerland

Pocket lighter in silver and enamel, with an Elma watch; c. 1926.

Svizzera
Accendino da tasca, in argento e smalto, con orologio Elma; c. 1926.

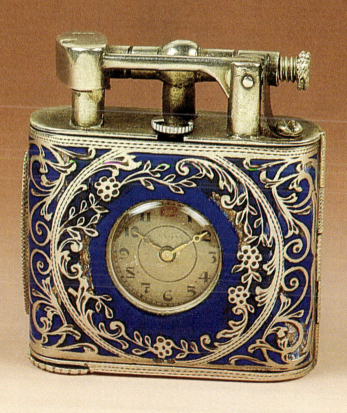

USA
Dunhill, Unique model

Enameled silver cigarette case with lighter; c. 1926.

USA—Dunhill—modello Unique
Portasigarette in argento e smalto con accendino; c. 1926.

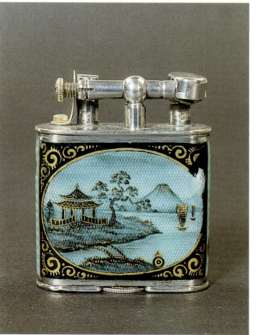

Great Britain
Dunhill, Unique A model

Enameled silver pocket lighter; c. 1926.

Gran Bretagna—Dunhill—modello Unique A
Accendino da tasca in argento e smalto; c. 1926.

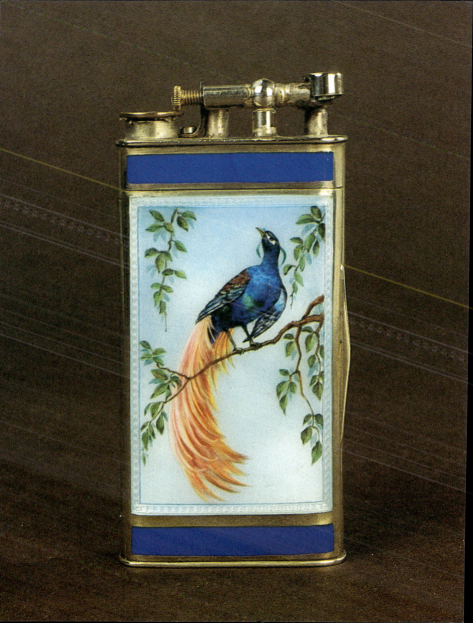

Great Britain
Dunhill, The Classic Jumbo

Table lighter in chromium-plated brass and Bakelite; c. 1928. Designed for bridge players.

Gran Bretagna—The Classic Jumbo
Accendino da tavolo in ottone cromato e bachelite; c. 1928. Questa È la versione proposta agli appassionati di bridge.

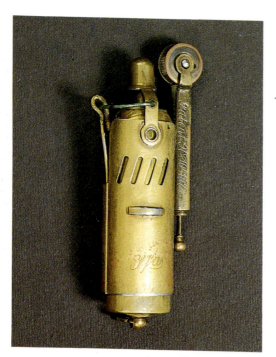

Austria
Imco, Ifa model

Brass pocket lighter; c. 1927.

Austria—Imco—modello Ifa
Accendino da tasca in ottone; c. 1927.

INTERNATIONAL CONTRACT BRIDGE OFFICIAL SCORING

For		Undoubled	Doubled
Each odd trick bid and won			
in clubs or diamonds	Tricks Score	20	40
in hearts or spades		30	60
in no trumps, 1st, 3rd, 5th, and 7th		30	60
2nd, 4th and 6th		40	80

		Not Vulnerable		Vulnerable	
		Un-d'bld	D'bld	Un-d'bld	D'bld
Each overtrick		trick value	100	trick value	200
*Undertrick penalties —					
First		50	100	100	200
Second		50	150	150	300
Third	Premium Score	50	200	200	400
Fourth		50	250	250	500
Fifth		50	300	300	600
Little slam bid and won		500		750	
Grand slam bid and won		1500		2250	
Honours in one hand—four honours of trump suit			100		
five honours of trump suit			150		
four aces when no trumps			150		
Rubber points —					
two-game rubber			700		
three-game rubber			500		
unfinished rubber for one game			300		

A redouble doubles the doubled points

N.B. Penalties in similar progression for further undertricks

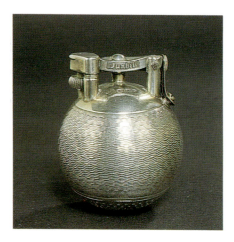

Great Britain
Dunhill, Ball model

Table lighter made of silver, in the shape of a ball. The earliest table model to be fitted with a double striking wheel; c. 1929.

Gran Bretagna—Dunhill— modello Ball
Accendino da tavolo in argento a forma di palla. Primo modello da tavolo con doppia rotella; c. 1929.

Great Britain
Dunhill

A lighter fuel container for refilling Dunhill lighters. It was screwed onto the petrol nozzle of the lighter and then turned over. In silver with gold-plated bands and gold initials; c. 1928.

Gran Bretagna—Dunhill
Serbatoio e distributore di benzina per accendini Dunhill. Si avvita il contenitore sull'orifizio benzina dell'accendino e poi si capovolge. In argento con strisce dorate ed iniziali in oro; c. 1928.

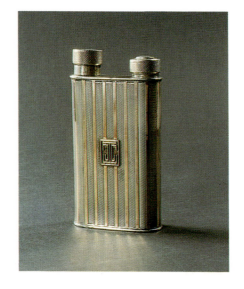

Great Britain
Dunhill, Vanity model

Handbag lighter in silver-plated brass, containing a lipstick case and powder case with mirror; c. 1929.

Gran Bretagna—Dunhill—modello Vanity
Accendino da borsetta in ottone argentato che contiene un portarossetto e un portacipria dotato di specchietto; c. 1929.

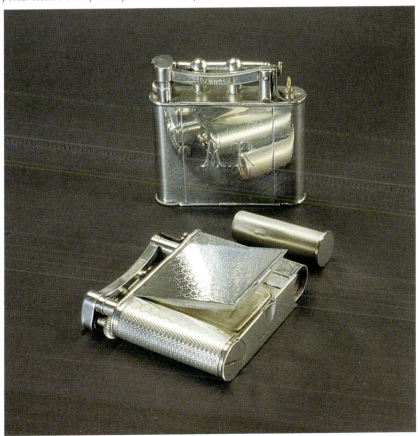

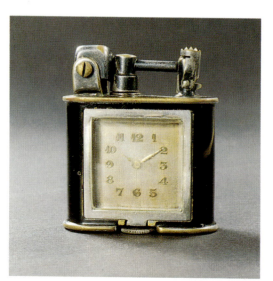

France
Lancel, Automatique model

Pocket lighter in silver-plated and lacquered brass, with a large watch; c. 1929.

Francia—Lancel—modello Automatique
Accendino da tasca in ottone argentato e laccato, con grande orologio; c. 1929.

France
Lancel, Automatique model

Pocket lighter in silver-plated brass in polished shagreen, or sharkskin; c. 1929.

Francia—Lancel—modello Automatique

Accendino da tasca in ottone argentato e ricoperto di pelle di pescecane levigata; c. 1929.

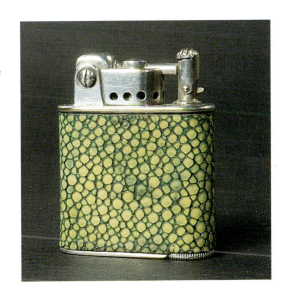

France
Flamidor, Ouragan model

Pocket lighter with a braided wick, made of brass plated with silver and gold; c. 1930.

Francia—Flamidor—modello Ouragan
Accendino ad esca intrecciata, da tasca, in ottone dorato e argentato; c. 1930.

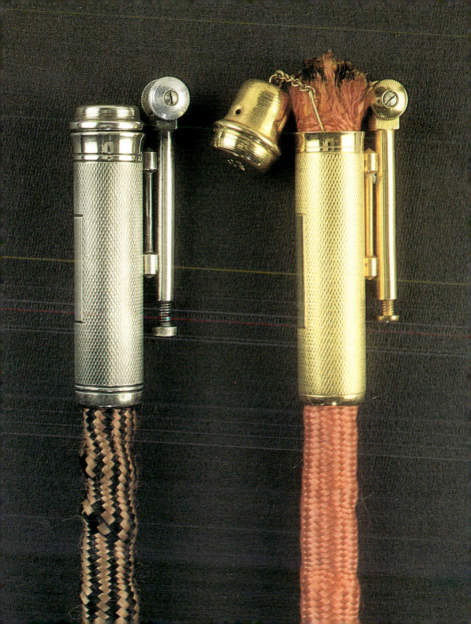

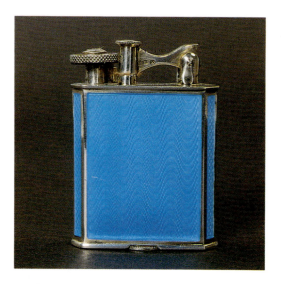

Switzerland
Pall Mall

A silver pocket lighter with enameled decoration. The flint is in the upright position; c. 1930.

Svizzera—Pall Mall
Accendino da tasca, in argento e smalto. La pietrina è in posizione verticale; c. 1930.

Switzerland

Silver pocket lighter with enamel-work and a watch by E. Gubelin (Lucerne). The hours on the face are marked with Masonic symbols; c. 1930.

Svizzera
Accendino da tasca in argento e smalto, con orologio E. Gubelin (Lucerne). Il quadrante raffigura le ore con simboli massonici; c. 1930.

➤

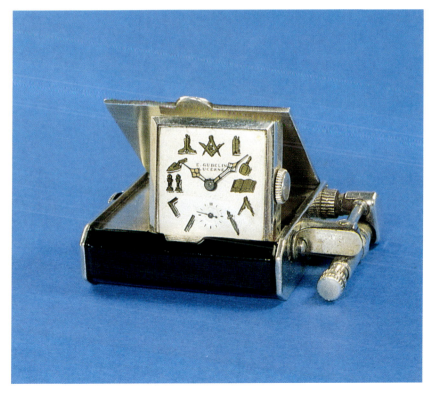

Great Britain
Dunhill, Bevelled model

Pocket lighter made of gold-plated brass, in elongated hexagonal shape; c. 1932.

Gran Bretagna—Dunhill—modello Bevelled
Accendino da tasca a forma esagonale allungata, in ottone dorato; c. 1932.

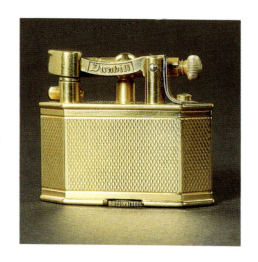

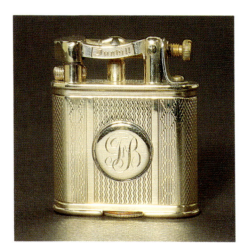

Great Britain
Dunhill, Unique A model

Nine-carat gold pocket lighter with initial; c. 1932.

Gran Bretagna—Dunhill—modello Unique A
Accendino da tasca in oro 9 ct. con iniziali; c. 1932.

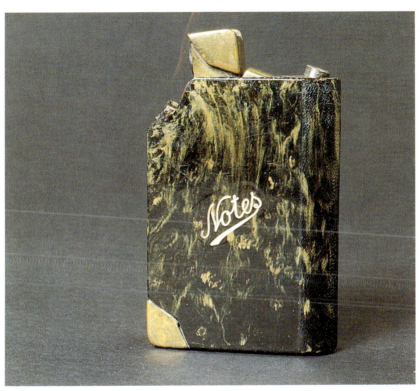

Germany
Notes model

Pocket lighter in the form of a notebook. Gold-plated brass and Bakelite; c. 1932.

Germania—modello Notes
Accendino da tasca a forma di taccuino. Ottone dorato e bachelite; c. 1932.

Great Britain
Dunhill, Unique model

Silver table lighter with eight-day clock; c. 1933.

Gran Bretagna—Dunhill—modello Unique
Accendino da tavolo in argento con orologio. Carica da otto giorni; c. 1933.

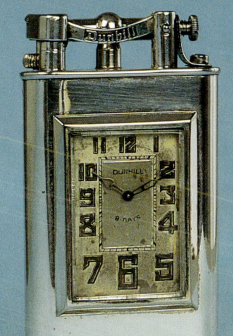

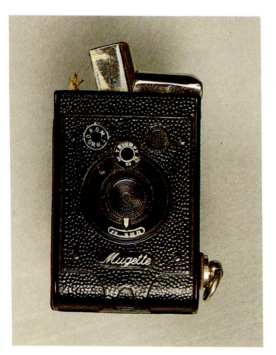

Germany
The Mugette pocket lighter

In the shape of a camera. Chromium-plated brass and Bakelite; c. 1933.

Germania—modello Mugette
Accendino da tasca a forma di macchina fotografica. Ottone cromato e bachelite; c. 1933.

France
The Polaire table lighter

In gold-plated brass, with large timepiece; c. 1933.

Francia—Polaire
Accendino da tavolo in ottone dorato con grande orologio; c. 1933.

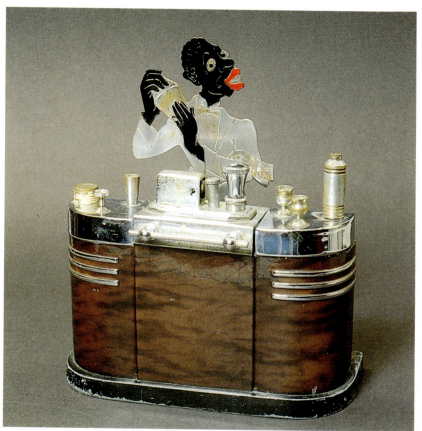

USA

Ronson, Art Metal Work Inc., Touch Tip model

Table lighter in chromium-plated brass and enamel. The mechanism is at center, concealed amongst bottles and glasses; c. 1935.

USA—Ronson—Art Metal Work Inc.—modello Touch Tip

Accendino da tavolo. Il meccanismo è al centro, dissimulato tra bottiglie e bicchieri. Ottone cromato e smalto; c. 1935.

USA
Ronson, Art Metal Work Inc., Touch Tip model

Table lighter in chromium-plated brass and enamel, with large timepiece; c. 1935.

USA—Ronson—Art Metal Work Inc.—modello Touch Tip
Accendino da tavolo, in ottone cromato e smalto, con grande orologio; c. 1935.

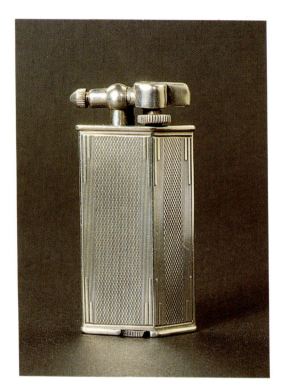

Great Britain
Parker, Beacon model

Silver pocket lighter with handsome rhomboid shape; c. 1935.

Gran Bretagna—Parker—modello Beacon

Accendino da tasca in argento con elegante forma romboidale; c. 1935.

Great Britain
Parker, Beacon model

Pocket lighter, probably designed for ladies, made of silver-plated brass covered in polished shagreen, or sharkskin; c. 1935.

Gran Bretagna—Parker—modello Beacon
Accendino da tasca, probabilmente per signora, in ottone argentato e ricoperto con pelle di pescecane levigata; c. 1935.

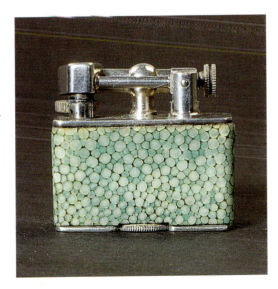

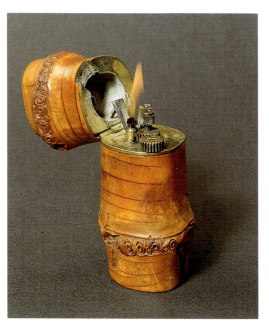

Great Britain
Dunhill, the Bamboo model

A table lighter set into a piece of bamboo; c. 1935.

Gran Bretagna—Dunhill—modello Bamboo

Accendino da tavolo contenuto in un pezzo di canna di bambù; c. 1935.

Great Britain
Dunhill, Unique Pipe model

Pocket pipe lighter. The wick carrier can be lifted so that the flame reaches the centre of the pipe bowl. Gold-plated brass. 1935.

Gran Bretagna—Dunhill—modello Unique Pipe

Accendino tascabile da pipa. Il portastoppino si può alzare per raggiungere con la fiamma il centro del fornello. Ottone dorato; c. 1935.

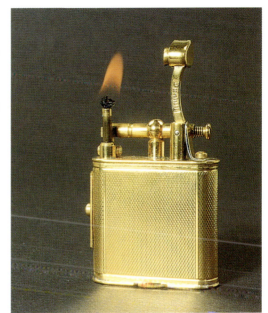

USA

Table lighter in chromium-plated metal, shaped like a ship's wheel. It was illustrated in the Dunhill–New York catalogue. It lights when the wheel is turned; c. 1935.

USA
Accendino da tavolo, in metallo cromato, a forma di timone da imbarcazione. Era anche illustrato nel catalogo Dunhill–New York. Si accende ruotando il timone; c. 1935.

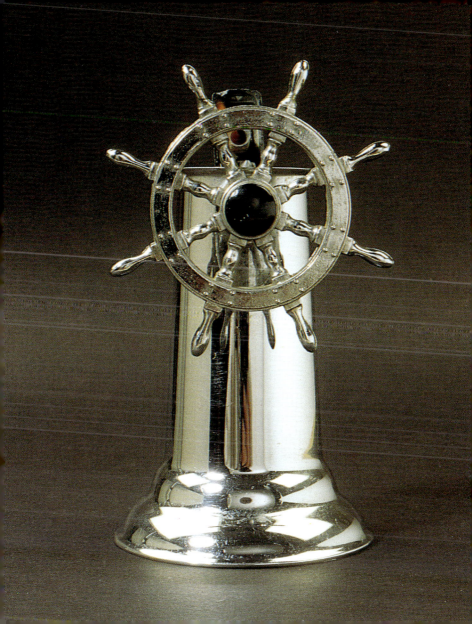

USA
Ronson, Art Metal Work Inc.

A table lighter with friction operation. A chromium-plated metal casting in the form of a donkey; c. 1935.

USA—Ronson—Art Metal Work Inc.
Accendino da tavolo a sfregamento. Fusione in metallo cromato che raffigura un asinello; c. 1935.

Austria
T.C.W. (Treibacher Chemische Werke)

Pocket lighter in chromium-plate. A curious design, recalling a pelican's head, with a beak that opens when the lighter is lit; c. 1935.

Austria—T.C.W. (Treibacher Chemische Werke)
Accendino da tasca in metallo cromato. Disegno curioso che ricorda la testa di un pellicano. Quando si accende apre il becco; c. 1935.

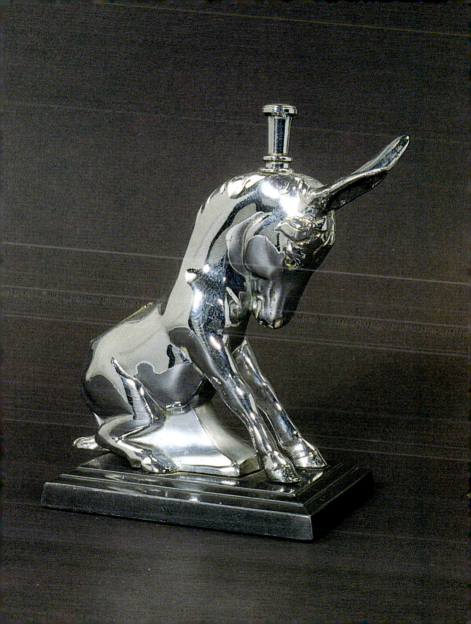

Germany
Mylflam

Chromium-plated brass pocket lighter with a silver band; c. 1935.

Germania—Mylflam
Accendino da tasca in ottone cromato con banda d'argento; c. 1935

France
Dandy

Cylindrical table lighter made of chromium-plated and enameled brass; c. 1935.

Francia—Dandy
Accendino da tavolo di forma cilindrica in ottone cromato e smaltato; c. 1935.

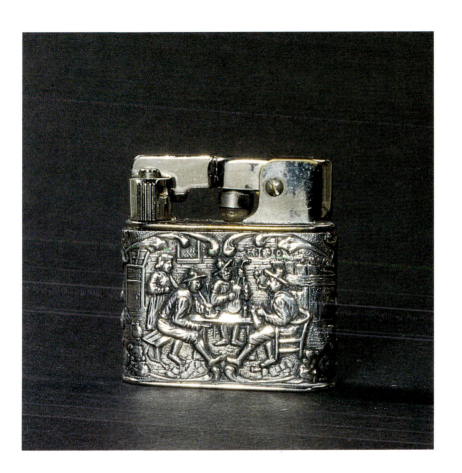

USA

Chromium-plated brass table lighter in the form of an airplane. It is lit by rotating the propeller; c. 1935.

USA
Accendino da tavolo in metallo cromato a forma di aereo. Si accende girando l'elica; c. 1935.

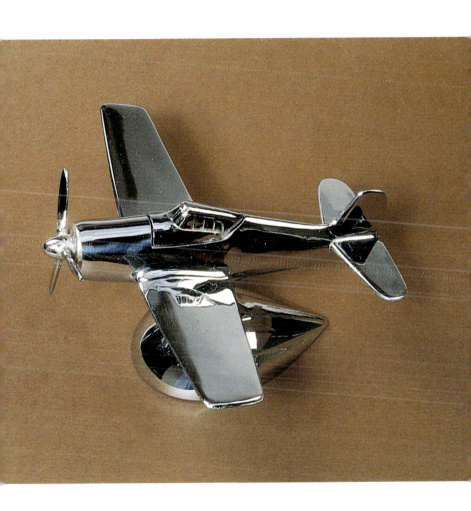

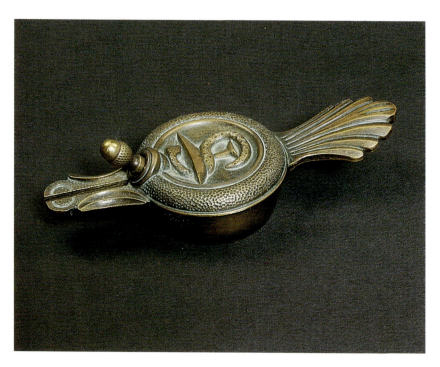

Germany
Siegfried model

A table lighter with friction operation. An attractive piece in cast bronze, shaped like an oil-lamp; c. 1935.

Germania—modello Siegfried
Accendino da tavolo a sfregamento. Bella fusione in bronzo a forma di lampada ad olio; c. 1935.

Great Britain
Dunhill, Roman Lamp model

A table lighter in silver, an object of class and quality; c. 1937.

Gran Bretagna—Dunhill—modello Roman Lamp
Accendino da tavolo in argento. Un oggetto raffinato e pregevole; c. 1935.

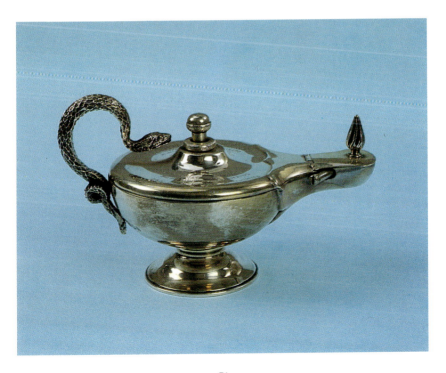

France Flamidor, marked "Unis, B.B.R., France"
Chromium-plated brass table lighter, enameled, with the game of dice; c. 1937.

Francia—Flamidor—Marcato "Unis, B.B.R., France"
Accendino da tavolo in ottone cromato e smalto con il gioco dei dadi; c. 1937.

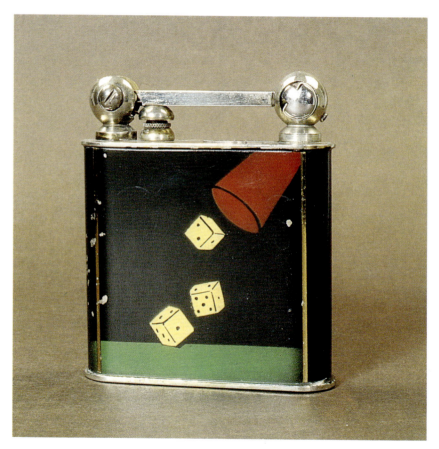

France
Myon, 401 Géant model

Chromium-plated brass table lighter with silver band, in Indochinese style; c. 1938.

Francia—Myon—modello 401 Géant

Accendino da tavolo in ottone cromato con fascia in argento di gusto indocinese; c. 1938.

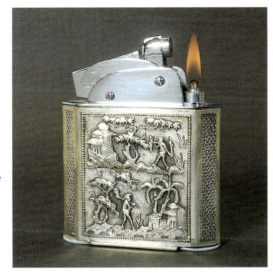

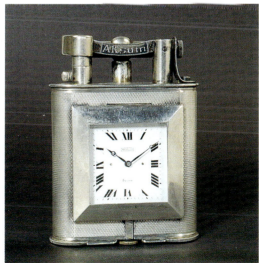

Italy
S. A. F. F. A., the Aksum model

Silver table lighter with an eight-day timepiece; c. 1938.

Italia—S. A. F. F. A.—modello Aksum

Accendino da tavolo in argento, con orologio. Carica da otto giorno; c. 1938.

Great Britain
Dunhill, The Light model

A table lighter shaped like a book. In brass and leather; c. 1938.

Gran Bretagna—Dunhill—modello The Light
Accendino da tavolo a forma di libro. In ottone e pelle; c. 1938.

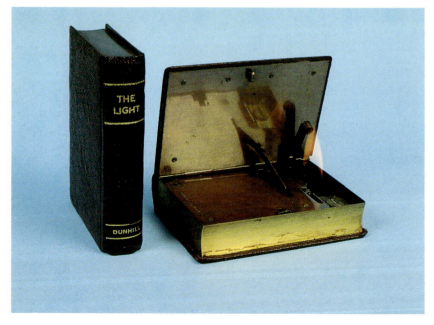

USA
Parker, Compact model

Lady's lighter in the form of a compact powder case, made of chromium-plated metal. It lights when the lid is lifted; c. 1938.

USA—Parker—modello Compact

Accendino per signora a forma di portacipria. In metallo cromato, si accende quando si alza il coperchio; c. 1938.

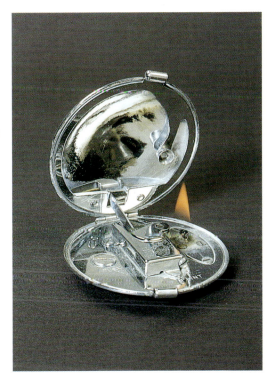

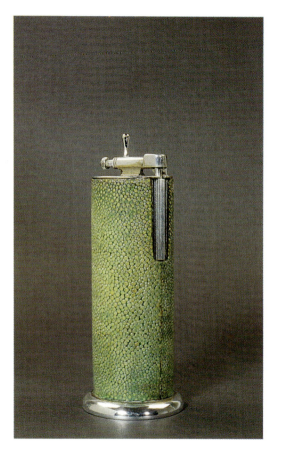

Great Britain
Parker, Roller Beacon model

Cylindrically shaped table lighter in chromium-plated brass and shagreen, or sharkskin; c. 1938.

Gran Bretagna—Parker—modello Roller Beacon

Accendino da tavolo, di forma cilindrica, in ottone cromato e pelle di pescecane; c. 1938.

USA
Negbaur

Table lighter in the form of a golfer's caddie. Cast and burnished metal; c. 1939.

USA—Negbaur
Accendino da tavolo a forma di sacca da golf. Fusione in metallo brunito; c. 1939.

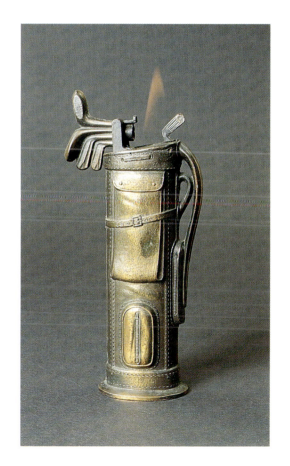

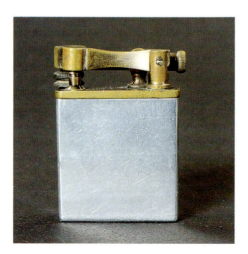

France
S. T. Dupont, model III

Pocket lighter made of gold-plated brass and Duralumin alloy; c. 1941.

Francia—S. T. Dupont—modello III
Accendino da tasca, in ottone dorato e duralluminio; c. 1941.

France
S. T. Dupont, model IV

Pocket lighter in gold-plated brass and Chinese lacquer, signed by the lacquerist. It was sold under the name of "Le Sultan"; c. 1942.

Francia—S. T. Dupont—modello IV
Accendino da tasca, in ottone dorato e lacca cinese firmata dall'artista laccatore. Veniva commercializzato con il nome "Le Sultan"; c. 1942.

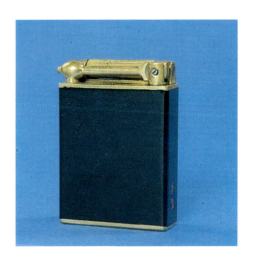

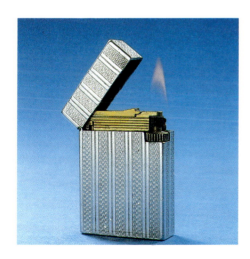

France
S. T. Dupont

The first of the company's parallelepiped models. Pocket lighter in Duralumin; c. 1942.

Francia—S. T. Dupont
Primo modello a forma di parallelepipedo della Casa. Accendino da tasca, in duralluminio; c. 1942.

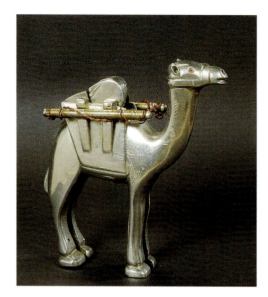

Africa

Handcrafted table lighter. Shaped like a dromedary (like the emblem of Camel cigarettes), it was made by the progressive removal of material from a solid block of heavy metal. It is lit by pressing the tail, and the hump flips up to reveal the flame. Probably crafted by a European ex-soldier in the former English or Italian colonies; c. 1946.

Africa

Accendino da tavolo, artigianale. Ha la forma di un dromedario (come quello delle sigarette Camel) ed è ricavato a mano, per asportazione, da un blocco di metallo pesante. Per accendere si preme la coda, e la gobba si alza liberando la fiamma. Probabile lavoro, nelle ex-colonie inglesi o italiane, di un ex-militare europeo; c. 1946.

Great Britain

Two pocket lighters in solid aluminum; c. 1946. On the left, a model with two lateral wheels and a central wick. On the right, a model with two lateral wheels and two central wicks.

Gran Bretagna
Due accendini da tasca in alluminio massiccio; c. 1946. A sinistra: due rotelle laterali e stoppino centrale. A destra: due rotelle laterali e due stoppini centrali.

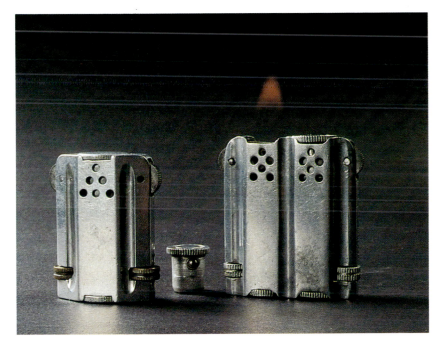

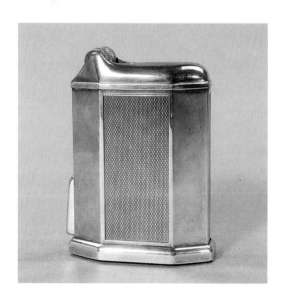

France
Flaminaire, Gentry model

Table lighter in silver-plated brass. The world's first butane-fueled lighter. It was presented in Paris on June 19, 1947.

Francia—Flaminaire—modello Gentry
Accendino da tavolo, in ottone argentato. Il primo accendino a gas nel mundo. Fu presentato a Parigi il 19 giugno 1947.

France
S. T. Dupont, Jéroboam model

Table lighter in gold-plated brass and Chinese lacquer; c. 1947.

Francia—S. T. Dupont—modello Jéroboam
Accendino da tavolo, in ottone dorato e lacca cinese; c. 1947.

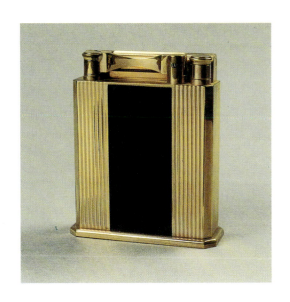

Germany
Kaschie

A table lighter, in chromium-plated brass, with decorations of birds in flight; c. 1947. Marked "U.S. Zone–Germany."

Germania—Kaschie
Modello da tavolo, in ottone cromato, con decorazione di uccelli in volo; c. 1947. Marcato "U.S. Zone–Germany." c. 1947.

➤

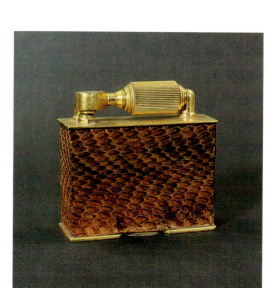

Great Britain
McMurdo

Gold-plated brass table lighter, sheathed with snakeskin; c. 1947.

Gran Bretagna—McMurdo
Accendino da tavolo in ottone dorato e fasciato con pelle di serpente; c. 1947.

◄

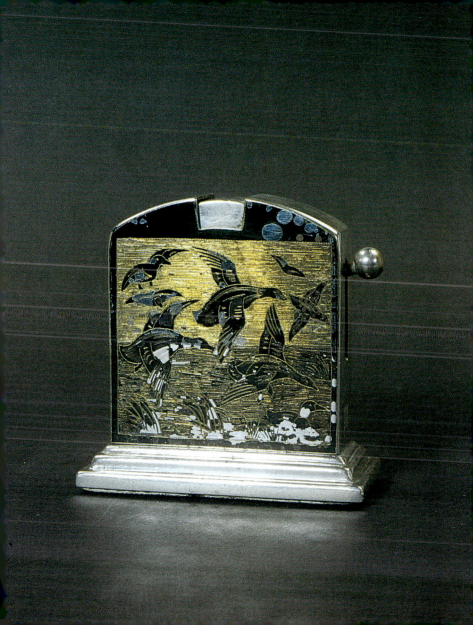

Great Britain
Dunhill

On the left, the Long Handy table model, in gold-plated brass; c. 1948. Above, the Square Boy pocket model; c. 1937. Below, the Handy pocket model; c.1939.

Gran Bretagna—Dunhill
A sinistra, modello Long Handy, da tavolo, in ottone dorato; c. 1948. In alto, modello Square Boy, da tasca; c. 1937. In basso, modello Handy, da tasca; c. 1939.

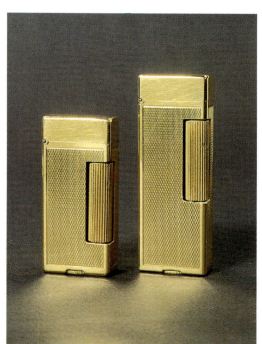

Great Britain
Dunhill, Rollalite model

Gold-plated brass pocket lighter, in miniature and full-sized versions; c. 1948.

Gran Bretagna—Dunhill—modello Rollalite
Accendino da tasca in ottone dorato, nella misura piccola e normale; c. 1948.

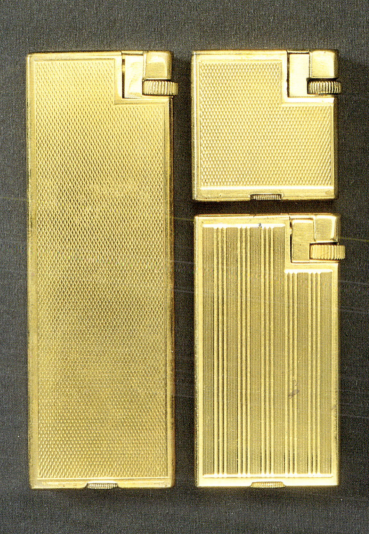

Great Britain
Dunhill, Compendium Case model

As well as a lighter and cigarette case, this model contains a watch, pencil, and pipe-tool. Nine-carat gold; c. 1948.

Gran Bretagna—Dunhill—modello Compendium Case
Oltre all'accendino e al portasigarette, è dotato di orologio, matita e curapipa. Oro 9 ct; c. 1948.

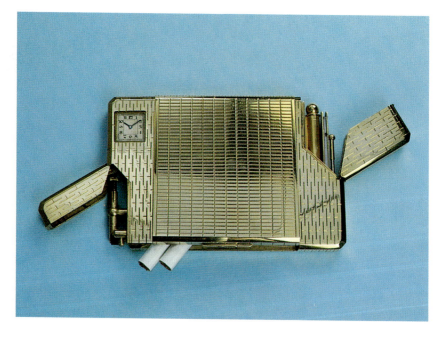

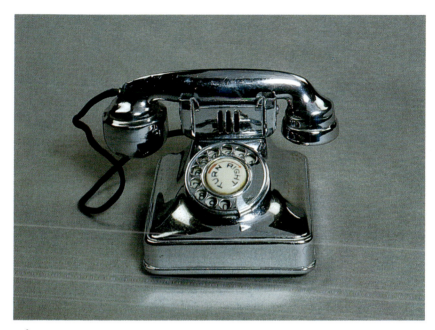

Japan
Peacock model

Table lighter in the shape of a telephone, made in chromium-plate; c. 1948. It is operated by lifting the handset and turning the dial. Marked "Made in Occupied Japan."

Giappone—modello Peacock
Accendino da tavolo, in metallo cromato, a forma di telefono; c. 1948. Per accendere, si solleva la cornetta e si gira il disco numerico. Marcato "Made in Occupied Japan."

Japan
K. K. W.

A model designed for both table and pocket. The tripod and cable release can be unscrewed. Marked "Made in Occupied Japan," on both the lighter and the tripod. Chromium-plated brass and plastic; c. 1948.

Giappone—K. K. W.
Modello sia da tasca che da tavolo. Il treppiede ed il flessibile si possono svitare. Marcato "Made in Occupied Japan" sia sull'accendino, sia sul treppiede. Ottone cromato e materiale plastico; c. 1948.

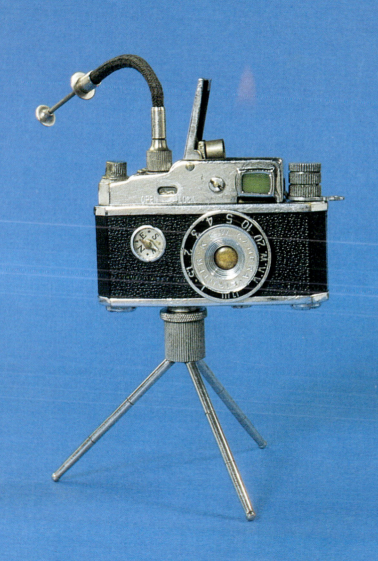

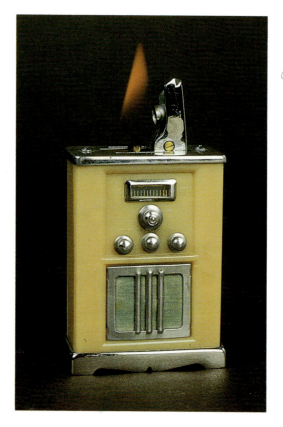

Japan
P. K. S.,
The Radio-Lite model

Radio-shaped table lighter made in chromium-plate and plastic; c. 1948. Marked "Made in Occupied Japan."

Giappone—P. K. S.—modello Radio-Lite

Accendino da tavolo, a forma di radio, in metallo cromato e plastica; c. 1948. Marcato "Made in Occupied Japan."

USA
Ronson, Art Metal Work Inc., Penciliter model

A pencil and lighter combined. On the left, the chromium-plated model dated 1936. On the right, the gold-plated model, 1948.

USA—Ronson—Art Metal Work Inc.—modello Penciliter

Matita con accendino. A sinistra, in ottone cromato, quella del 1936. A destra, in ottone placcato oro, quella del 1948.

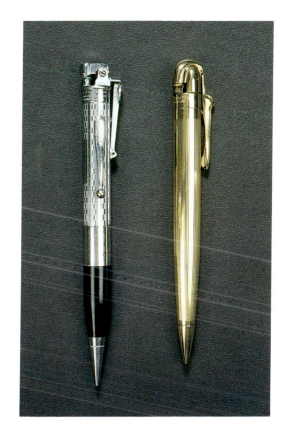

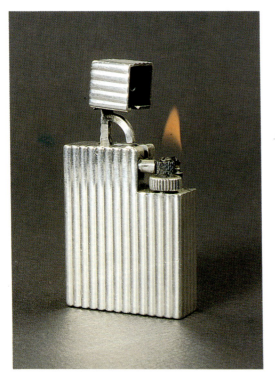

France
Cartier

Silver pocket lighter; c. 1949.

Francia—Cartier
Accendino da tasca in argento; c. 1949.

France
Cartier

Silver table lighter (detail); c. 1949.

Francia—Cartier
Accendino da tavolo in argento (particolare); c. 1949.

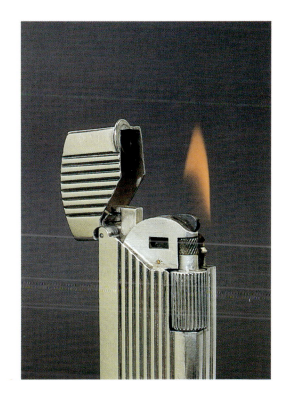

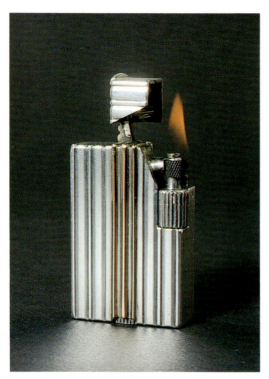

France
Dunhill Paris, Alduna model

Pocket lighter in silver and gold; c. 1949.

Francia—Dunhill Paris—model Alduna
Accendino da tasca in argento e o:
c. 1949.

Candelite model

Table lighter in the shape of a candlestick holder, in chromium-plated metal with enameling; c. 1950. Marked "Foreign," in other words, sold in Great Britain but made elsewhere.

Modello Candelite
Accendino da tavolo a forma di portacandela, in metallo cromato e smaltato; c. 1950. Marcata "Foreign" e cioè venduta in Gran Bretagna, ma non li costruita.

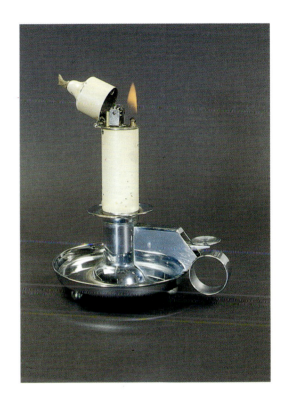

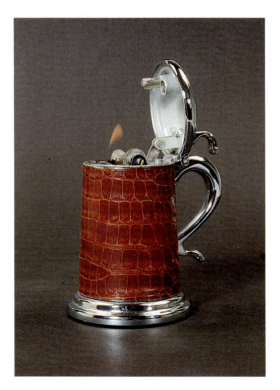

Great Britain
Dunhill, Bumper or Tankard model

Table lighter in chromium-plated brass with leather sheathing; c. 1950.

Gran Bretagna—Dunhill—modello Bumper o Tankard

Accendino da tavolo in ottone cromato con fascia in pelle; c. 1950.

Great Britain
Dunhill, Aquarium model

Table lighter in silver-plated brass and Perspex; c. 1950.

Gran Bretagna—Dunhill—modello Aquarium
Accendino da tavolo in ottone argentato e Perspex; c. 1950.

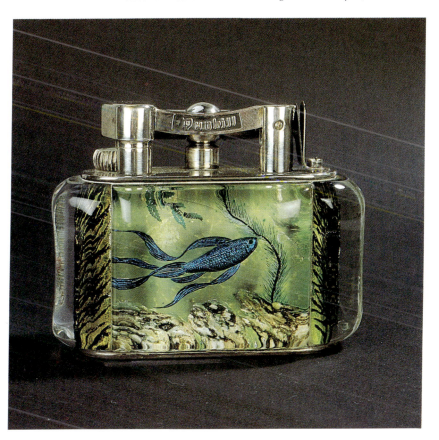

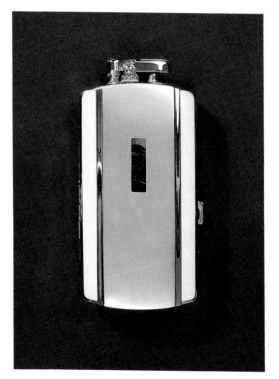

USA
Ronson

Cigarette case with lighter. An elegant design for women, in satin-finish metal with enameling; c. 1950.

USA—Ronson

Portasigarette con accendino. Di forma elegante, per signora, è in metallo satinato e smaltato; c. 1950.

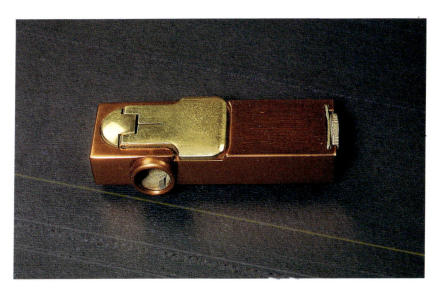

France
Transfo model

It lights a cigarette or pipe using just the sparks produced by the flint. The cigarette is inserted into the hole and the key is turned. In burnished and gold-plated metal; c. 1950.

Francia—modello Transfo
Accende la sigaretta o la pipa con le sole scintille della pietrina. Si infila la sigaretta nel buco e si ruota la chiavetta. In metallo brunito e dorato; c. 1950.

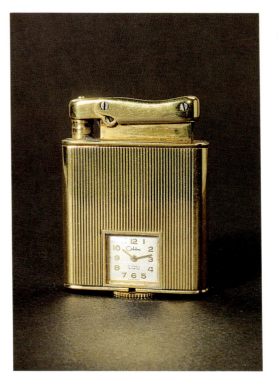

Great Britain
Colibri, Monopol model

Gold-plated pocket lighter with Swiss watch; c. 1950. This model, produced in various sizes and versions, was widely sold: a gas-filled type named Monogas was also made.

Gran Bretagna—Colibri— modello Monopol

Accendino da tasca, in ottone dorato, con orologio svizzero; c. 1950. Costruito in varie misure e versioni, questo modello ebbe un buon successo commerciale e fu prodotto anche a gas con il nome Monogas.

France
Flaminaire, Champion Orfevrerie model, Gallia type

Butane-filled table lighter; c. 1952. The exterior part consists of a casting of a high-silver metal alloy. Inside it contains the Champion pocket model.

Francia—Flaminaire—modello Champion Orfèvrerie—tipo Gallia

Accendino da tavolo a gas; c. 1952. La parte esterna consiste in una fusione di metallo ad alta percentuale di argento. All'interno vi è il modello da tasca Champion; c. 1952.

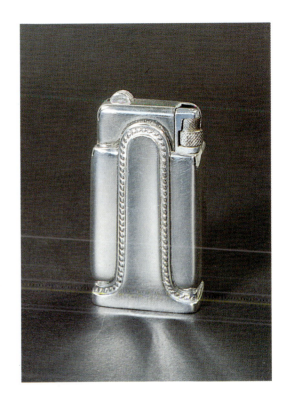

Germany
"Weltzünder" mark

A set in chromium-plated brass and lizard skin, consisting of a lighter and cigarette case, with space for face-powder and lipstick; c. 1950.

Germania—marcata "Weltzünder"
Completo in ottone cromato e pelle di lucertola composto da un accendino e un portasigarette con scomparti per la cipria ed il rossetto; c. 1950.

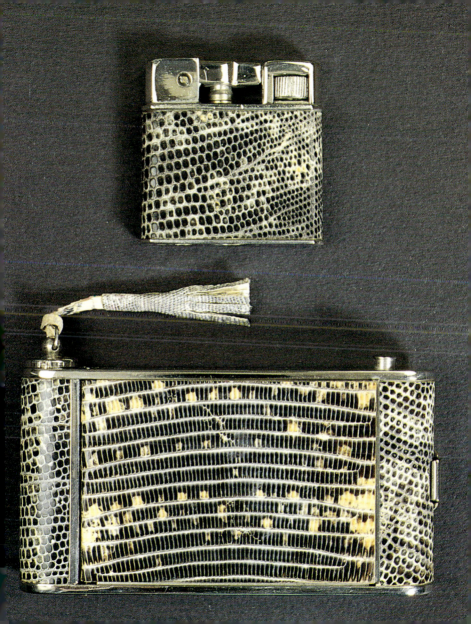

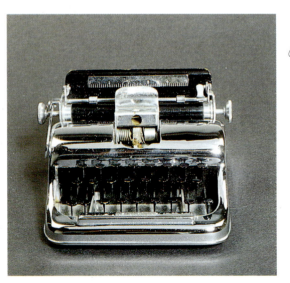

Japan

Table model in chromium-plated alloy, in the shape of a typewriter. It is lit by pressing the space-bar; c. 1952.

Giappone
Modello da tavolo, in lega di metallo cromato, a forma di macchina da scrivere. Per accendere si preme la barra spaziatrice; c. 1952.

France
S. T. Dupont, model D 57

*P*ocket lighter made of gold-plated brass with Chinese lacquer-work. The first butane-filled design to be produced by this manufacturer, it was presented on December 18, 1953.

Francia—S. T. Dupont— modello D 57

Accendino da tasca, in ottone dorato e lacca cinese. Primo modello a gas della casa. Fu presentato il 18 dicembre 1953.

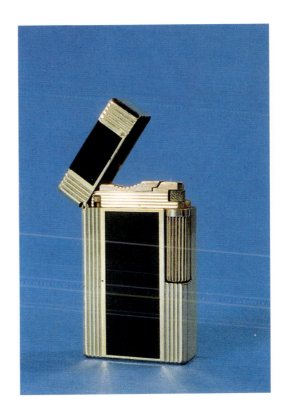

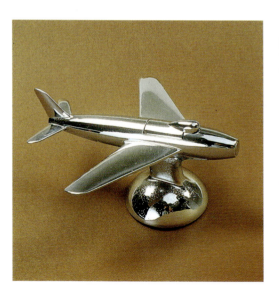

Great Britain
Dunhill, Jet Plane model

Chromium-plated brass table lighter in the shape of a jet. It is used by pressing the button on the nose; c. 1954.

Gran Bretagna—Dunhill—modello Jet Plane

Accendino da tavolo a forma di aereo a reazione in ottone cromato. Per accendere si preme il bottone posto sul muso; c. 1954.

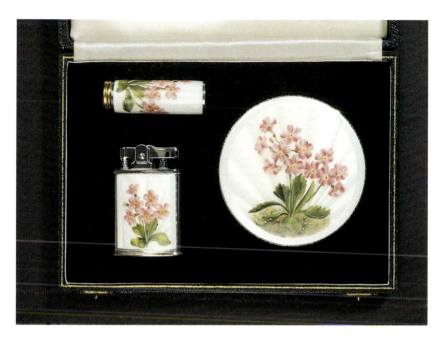

Great Britain
Ronson

A set that includes a lighter, lipstick case, and powder case. In silver and enamel with a floral motif, the perfect gift for a woman smoker; c. 1954.

Gran Bretagna—Ronson
Completo composto da un accendino, un portarossetto e da un portacipria. In argento e smalto con motivo floreale. Un gradito regalo per una signora fumatrice; c. 1954.

Great Britain
Ronson, Newport model

Table lighter in silver-plated brass; c. 1955.

Gran Bretagna—Ronson—modello Newport
Accendino da tavolo in ottone argentato; c. 1955.

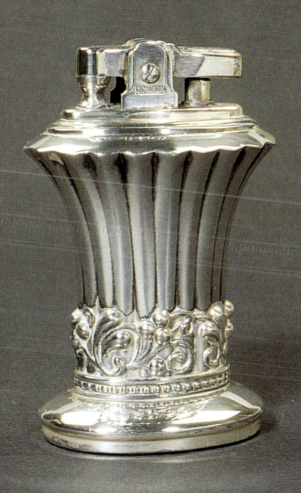

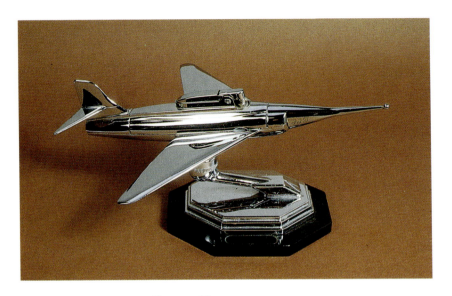

Great Britain

Table model in the form of a jet airplane, made of chromium-plated brass and mounted on an articulated arm; c. 1956.

Gran Bretagna
Modello da tavolo a forma di aereo jet, in ottone cromato. È dotato di braccio snodato; c. 1956.

Germany
Rowenta

Table lighter in chromium-plated brass, with a dragon engraved on an enameled ground; c. 1957.

Germania—Rowenta
Accendino da tavolo, in ottone cromato, con l'incisione di un drago su smalto; c. 1957.

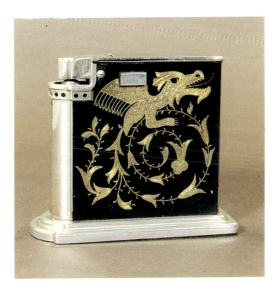

France
Flaminaire, Baronet Oxford model

A butane-filled table model in gold-plated brass and ponyskin; c. 1958.

Francia—Flaminaire—modello Baronet Oxford
Da tavolo a gas, in ottone dorato e pelle di cavallino; c. 1958.

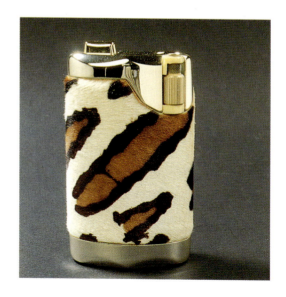

Switzerland
The Tiki Gala model

A table lighter in chromium-plated and enameled brass; c. 1960. The removable base contains a music box marked "Reuge, Ste Croix."

Svizzera—modello Tiki Gala
Da tavolo, in ottone cromato e smaltato; c. 1960. La base è sfilabile e contiene un carillon marcato "Reuge, Ste Croix."

Great Britain
Ronson, Minton model

A table lighter in chromium-plated brass, fitted into a hand-painted bone china base, signed by the artist; c. 1960.

Gran Bretagna—Ronson—modello Minton
Accendino da tavolo in ottone cromato, inserito in una base di porcellana (bone china) dipinta a mano e firmata dall'artista; c. 1960.

Great Britain
Ronson, Wedgwood model

A table lighter in chromium-plated brass, with a classical Wedgwood base; c. 1960.

Gran Bretagna—Ronson— modello Wedgwood

Da tavolo, in ottone cromato, inserito in una base con la nota decorazione di Wedgwood; c. 1960.

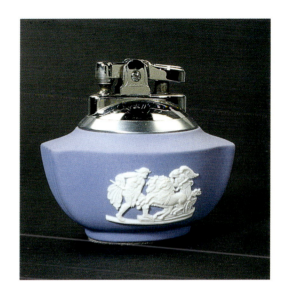

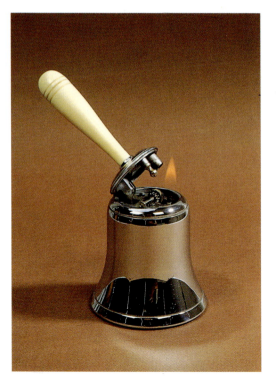

Great Britain
Dunhill, Bell model

A table model in chromium-plated brass with a resin handle; c. 1960. The bell shape was designed as an approximation to the type of bell used to summon servants during a meal.

Gran Bretagna—Dunhill—modello Bell

Da tavolo, in ottone cromato ed impugnatura in resina; c. 1960. La forma a campanello venne realizzata per renderlo simile a quello che, all'epoca, serviva per chiamare i domestici durante il pranzo.

Great Britain
Dunhill

On the left, the Sylphide Paris, pocket model in gold-plated silver, butane-fueled; c. 1961. On the right, the Sylph London pocket model in gold-plated brass, gas-fueled; c. 1953.

Gran Bretagna—Dunhill
A sinistra, modello Sylphide Paris, da tasca, in argento placcato oro, a gas; c. 1961. A destra, modello Sylph, London, da tasca, in ottone dorato, a benzina; c. 1953.

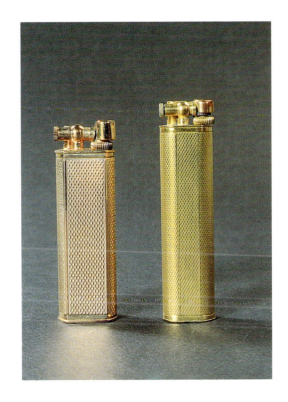

Great Britain
Dunhill, Tinder Pistol model

A table lighter in the form of a famous type of tinder pistol. Burnished metal with wooden handle; c. 1962.

Gran Bretagna—Dunhill—modello Tinder Pistol

Accendino da tavolo che imita un famoso tipo di acciarino. Metallo brunito ed impugnatura in legno; c. 1962.

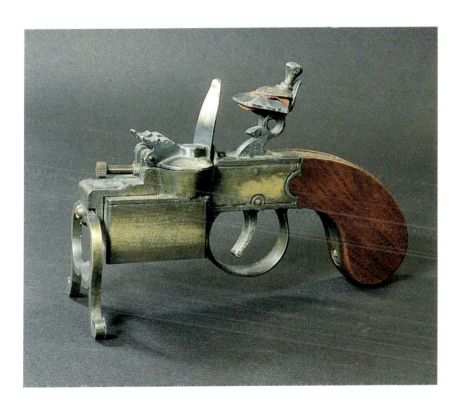

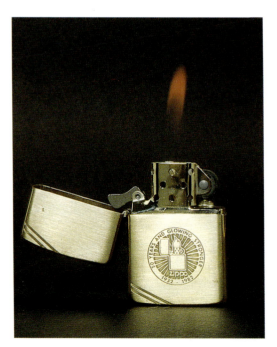

USA
Zippo

A classic pocket lighter in brushed brass. Made to commemorate the fiftieth anniversary of the company, in 1982.

USA—Zippo
Modello classico, da tasca, in ottone spazzolato. Commemora in cinquantenario della casa, celebrato nel 1982.

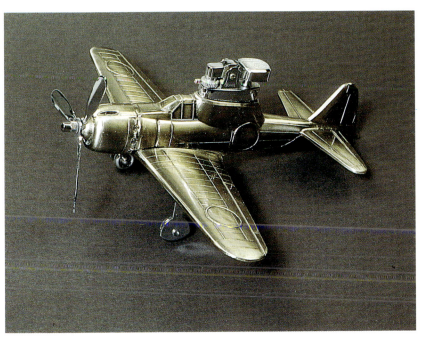

Japan
Penguin

A table lighter in the form of a model of the Japanese "Zero Fighter 52," famous for its role in World War II. Cast metal with a removable, butane-filled lighter; c. 1982.

Giappone—Penguin
Modello da tavolo che riproduce l'aereo da caccia giapponese "Zero Fighter 52," usato nella II guerra mondiale. Fusione in metallo con accendino a gas estraibile; c. 1982.

A Bit of History

In the late nineteenth century, the use of petrol, together with the lighter-flint developed by the Austrian scientist Auer von Welsbach, permitted the invention of the modern lighter—the subject of this book.

Carl Auer von Welsbach was born in Vienna in 1858, and he lived until 1929 (he died in the family castle of Welsbach). He studied at Heidelberg with the great physicist Bunsen and in the early 1880s began research on the rare earth metals, work that he was later to continue in Vienna. In 1884 he described a method of obtaining a pure cerium; the following year he invented a cotton mantle that became incandescent when heated by a gas flame, producing the so-called "Auer light." He also devised lamps with osmium and tungsten filaments. On July 27, 1903, he filed an application for the patent of the flint, granted on October 1, 1904, and published on February 25, 1905, in Austria, with the number 19251. The text of the patent, entitled "Pyrophoric metal alloys," includes the following on its first page:

"According to a number of scientists, the rare earth metals possess the property of producing inflammable sparks when scratched with hard cutting materials. However, experiments have shown that this is not true; in other words, these metals do not possess this unusual quality. In fact the absence of the self-ignition of detached particles is one of the characteristics that distinguishes highly pure rare earth metals. However it has been proved that these metals are pyrophoric when alloyed to other metals, particularly iron. Even an alloy with a low iron content produces sparks when rubbed with a pointed object. The higher the content of iron, the more intense its spark production. At first, sparks are released, then an intense light develops; when the alloy cotains 30% iron, it has the maximum pyrophoric effect. An alloy of this type is so sensitive that the mere contact with another rough material is sufficient to form sparks. If the iron content is further increased, the alloy's pyrophoric nature progressively decreases; however it is still present with a content of 75%, particularly if the body is heated. [. . .] It has been found that the particles, which are readily detached by scratching and which burn rapidly in the presence of air, can ignite gases or other highly inflammable substances or objects, such as a fuse or a wick soaked in petrol."

A ferrous alloy of cerium was used in the so-called friction lighter, which had a piece attached to one side. The body of the lighter contained cotton impregnated with petrol, and a hollow rod containing

a wick was fixed to the base. By rubbing the ferrous cerium alloy rods, sparks were produced, igniting the wick. Large numbers of these very successful lighters were manufactured, both in brass and in finely worked precious metals.

The simple friction rod was later replaced by a knurled, or ridged, steel wheel that was rotated while in contact with the flint. The flint itself was cylindrical, of a diameter suited to the size of the strike wheel, and slid in a tubular housing with a spring that maintained a constant pressure between flint and wheel. Petrol, wick, strike-wheel and flint were universally used for lighters until 1947, when the butane-filled lighter was introduced in Paris.

Manufacturing Companies
IMCO — Austria

The name IMCO stands for "Oesterreichische Feuerzeug und Metallwarenfabric J. Meister & Co." Founded in 1907 for the production of buttons, IMCO began to make lighters after World War I. The earliest types were crafted from cartridge cases, but later many interesting lighters were made from the company's own designs and patents. It is believed that they also worked under license, producing lighters for companies who wished to have their own trademark on the product. The archives containing the company's earliest documents were

destroyed during World War II, and so for many models one has to rely on a few rare catalogue illustrations.

T. C. W. — AUSTRIA

This company is significant in that it was founded in 1907 by Carl Auer von Welsbach for the industrial production of the lighter-flint of his invention. After a few years, flints were manufactured under licence in many nations, and the alloy from which they were made was often known as Auermetall. The company marketed several types of lighters under its own name, but they were actually made by other manufacturers.

CARTIER — FRANCE

The Cartier family, jewelers for one hundred and fifty years, began work in Paris in the days of Louis Philippe. Louis-François Cartier (1819—1904) became a supplier to the king; success was assured by numerous, prestigious, aristocratic clients. He introduced his first lighter in 1867, probably on the occasion of the Paris Universal Exhibition.

What sort of lighter was it? Though there is no documentary evidence, one can assume that it was an ornate and valuable tinder-box (containing tinder and flint), with the fire-steel fitted to one side.

In 1872, Louis-François's son Alfred (1841–1925) joined the firm; in 1898, under the directorship of Louis-Joseph (1875–1942), Alfred's eldest son, the company moved to its present locaton in Rue de la Paix.

At the end of World War I, many lighters were produced, both friction and strike-wheel versions. They were not just functional objects, but jewels made in limited numbers, often according to the specific demands of the client. Thus there are many variants for each model, and many of them are unique pieces.

Louis-Joseph married the daughter of the famous English tailor, Worth, and his clients included the Prince of Wales, later to become King Edward VII.

These friendly relations with the British crown helped Pierre Cartier (1878–1964) found Cartier-London in 1902: the branch was later directed by Jacques Cartier (1884–1941), Alfred's third son. In 1908, Pierre also founded Cartier—New York. Louis-Joseph was responsible for the archive in which all Cartier pieces, including the lighters, were catalogued.

After the 1950s, the branches in Paris, London, and New York were acquired by different groups, but between 1972 and 1976, Robert Hocq (1917–1979) took on the presidency of Cartier–Paris, Cartier–London, and Cartier–New York. A French businessman, Hocq was the owner of Silver Match, which had made butane-filled lighters for

Cartier from 1968 on; Cartier's first butane lighter, the Ovale, was presented in 1968.

FLAMIDOR — FRANCE

This was the first trademark used by the Quercia company, which manufactured petrol-filled lighters only. The company was founded by Janvier Quercia, who had emigrated from Italy as a youth (changing his first name from Gennaro); he was a descendent of Jacopo della Quercia, Michelangelo's teacher. Janvier opened a successful shop in Paris in 1890, creating religious objects in precious metals.

When Carl Auer von Welsbach patented the lighter-flint, Quercia made a number of friction lighters in silver. In 1908 he constructed his first petrol lighter fitted with a flint wheel, named Flamidor. In 1911 he introduced the model Briquet Parisien (a lighter with a removable cover, like the Zippo), making versions in beautifully crafted silver and gold. The model was highly successful and was produced for over ten years.

Janvier's son Marcel (1900—1975) joined the firm at the age of twenty-four. He increased production by commissioning other manufacturers to make his products. In 1935, when Janvier died, Flamidor was the most important lighter factory in France Marcel, an engineer, registered many patents and continued to produce petrol lighters after World War II.

FLAMINAIRE — FRANCE

The Flaminaire trademark was owned by the Quercia family as early as the 1930s, but was used exclusively for butane lighters. The earliest research toward the construction of the butane lighter dates to 1935. Henri Pingeot, a bicycle-valve manufacturer from Clermont-Ferrand, built a prototype for a lighter with butane fuel and obtained a patent for it on December 19, 1935. When Marcel Quercia heard about this he immediately tried to buy the patent, although Pingeot was already negotiating with the German Company KW of Solingen (KW were the initials of the founder, Karl Wieden). In a gesture of patriotism Pingeot gave his invention to Quercia, who improved it and registered numerous patents with his colleague George Ferdinand.

During the German invasion of France, work continued and the design was further improved, but Quercia refused to comply with the demands of the occupying forces, who demanded to know what results had been achieved. After the war, Quercia commissioned Shell Butagaz to carry out research into a special butane for lighters. On June 19, 1947, the world's first butane lighter, a table model called Gentry, was presented at the Hotel Crillon, Paris. The advertising for this lighter emphasized the fact that Gentry had neither wick (replaced by a nozzle) nor petrol (replaced by butane). The flint and the fuel supply provided about two thousand lights, so that a person smoking twenty cigarettes a day could use it for almost a year and a half with no maintenance or refill.

Other models followed, all with sumptuous finish, in silver, gold, and Chinese lacquer. Their commercial success permitted Flaminaire to make excellent profits until the early 1960s, when many other manufacturers began to create competition.

L A N C E L — F R A N C E

Lancel was founded in Paris by the like-named family in 1876. The Lancels opened a shop selling pipes and other articles for smokers, and later extended their range to include leather goods. In 1928 Lancel began manufacturing petrol lighters in their own factory. Models were made in silver or with Chinese lacquer and some even incorporated a timepiece. In the early 1950s Lancel introduced a butane-filled lighter of the same design as the petrol model. Production ended in 1965.

M Y O N — F R A N C E

Myon (Anciens Établissements Myon & Cie) began manufacturing lighters in 1919, in a factory a few kilometers from the Swiss border. Many patents were registered in their name, and the company did much business with Flamidor and Flaminaire, for whom it had made lighters as early as the 1920s.

S. T. Dupont — France

In the early nineteenth century, the Tissot family owned a mill at Arcier, near Faverges in Haute Savoie. Because there was a bridge near the mill, villagers called them Tissot du Pont to distinguish the family from others with the same surname. In 1848, François Tissot Dupont went to Paris, and became a photographer, working with Crémière. When the latter died, Dupont took over the business and was made court photographer. He summoned his nephew Simon to Paris as an assistant, but after a few years he decided to change trades, and opened a leather goods workshop with Simon, making purses and travel cases. At the end of World War I, increasing demand from their high-class clientele convinced Simon Tissot to move to a large three-floor workshop. He was assisted by his sons Lucien and Andre, and he employed about a hundred skilled workers. The Great Depression that swept over Europe in 1929 forced him to close the Paris factory and move to Faverges, the family's hometown, with just a handful of employees. But the leather goods they crafted were even more sumptuous and beautiful than before, made from the finest leathers and most precious metals. In the 1930s they introduced their superb Chinese lacquered pieces, and cases that included a lighter. One of their clients, the maharajah of Patiala, expressed a desire to have a lighter in his travel case, and from then on the company added this accessory to all their cases; unfortunately none of these lighters is still in existence today.

During World War II, there was a shortage of both leather and customers. In order not to dismiss employees, the company decided to manufacture lighters on an industrial scale. In November 1940, André introduced the first S. T. Dupont lighter, which possibly resembled the model that they had crafted for their luxury travel cases; after a few months a second model was introduced. But shortages of brass caused by the war hampered production; in the following year another type was presented, with the top part in brass and the rest in Duralumin. The latter material was finally abandoned in April 1947.

The company's first butane-filled models reached the market on December 18, 1953, and records of production numbers were kept from this date on.

Rowenta — Germany

Rowenta was founded in 1884, near Frankfurt, for the manufacture of small metal items. In 1912, Robert Weintraud built his first electrical appliances in metal, and soon specialized in portable electrical appliances. He also made luxury items such as women's powder cases, and began making lighters after World War II.

COLIBRI—GREAT BRITAIN

In 1910, Julius Lowenthal (1892–1970) was employed by a German company dealing in articles for smokers. After World War I, he founded the company J. & B. Lowenthal (Jbelo) in Frankfurt, together with his brother Benno, for the manufacture of lighters and pipes.

In 1927 Julius had the idea of making a lighter that could be used without touching the strike-wheel with one's fingers. The following year, the Colibri Original was presented, its name derived from a term meaning "hummingbird." The lighter was made in Germany, Switzerland and England. During the 1930s, the company made design improvements, incorporated into the Monopol model; about twenty million examples were sold throughout the world.

In 1933 Julius moved to London, founding Colibri Lighter Limited. He was joined by his brother Benno, who set up a company named Benlow, and by his sister Meta, who had previously remained in Germany to direct Jbelo. The London headquarters and all the warehouses were destroyed in the bombing raids of 1940.

In 1955 the first butane-filled Colibri appeared, made in cooperation with Flaminaire; the model was named Flacco (Flaminaire & Colibri), and was made in France until 1958 with the Monopol mechanism.

DUNHILL — GREAT BRITAIN

Alfred Dunhill was thirty-five years old when, in July 1907, he opened his first shop on Duke Street, in the London borough of St. James. He had little experience in the tobacco trade, but he aimed to overtake the competition by studying the tastes of his customers. In the early years of the twentieth century, after the death of Queen Victoria, smoking was forbidden at Court. In order to smoke, men met in specially reserved rooms wearing "smoking jackets," the correct attire for savoring the aromatic vapors produced by the combustion of tobacco. For such connoisseurs Alfred Dunhill began creating a series of quality blends of tobaccos, described in his book, *My Mixture*.

Dunhill's first pipes were introduced in 1910. They were of excellent quality, made from the best briar and with higher prices than the competition, and quickly won repute and appreciation amongst his customers.

In 1922, the Dunhill–New York company was opened, with a catalogue that included various types of lighters made by other manufacturers. Toward the end of the year the first Dunhill lighter was offered. Named "Unique," six centimeters high, it was made for just a few years before being replaced by an identical, though smaller, model. The patent for this lighter was the result of an invention by Greenwood and Wise, who, in 1919, designed a device that could be lit using only one hand, and that had a horizontally mounted flint. The prototype was built in a cylindrical mustard-pot: it is now preserved in the Dunhill museum.

In 1924, the year in which Dunhill—Paris was founded, the fifty-two-millimeter-high Unique was presented, published in the first Parisian catalogue with the name Le Briquet Parfait (the perfect lighter). Only versions in precious metals were offered: 18-carat gold, silver, and gold-plated silver. The presentation of valuable lighters was to remain one of the characteristics of the Paris branch, even after the introduction of butane lighters.

The following year a smaller model was made, named Unique like the others but forty-six millimeters high. Later, the models were denoted with the letters C, B, and A, in inverse order with respect to the date of introduction. In the early years of lighter manufacture, no one expected the extraordinary commercial success that was to make classification of the various models necessary.

Alfred Dunhill retired in 1928, leaving the management of the company to his brother Bertie. His daughter Mary, born in 1906, had already joined the firm.

In 1929, the Unique Sport, a pocket model, and the Ball table model were produced, the first to have a double strike-wheel, an improvement considered to make the lighter more convenient for women to use. From 1932 this feature was applied to all models.

The old strike-wheel, in contact with a flint, was dirty and necessarily abrasive. Anyone using a lighter, particularly a heavy smoker, risked dirtying or even cutting a thumb. The double-strike wheel simply transmitted the movement and so remained clean and pleasant to use.

Many customers sent their old lighters back to Dunhill to be fitted with a double strike-wheel.

An important Swiss factory, La Nationale, was commissioned to make many models, including some with watches, in order to meet the continuous demand. This joint venture, particularly successful during World War II for supplying foreign markets, is still in operation.

The first of Dunhill's butane lighters was the Rollagas model, introduced in 1956, and still made today with a number of different finishes.

PARKER — GREAT BRITAIN

Parker Pipe Ltd. was founded by Alfred Dunhill in 1923, as a trademark for pipes and lighters. It manufactured both pocket and table versions of petrol-filled lighters, some of which were in beautifully finished silver. Dunhill–Paris made a number of economical pocket Parker lighters.

S. A. F. F. A. — ITALY

The company named Saffa was founded in Milan in 1928 (its name standing for Società Anonima Finanziaria Fiammiferi e Affini). It took over Fabbriche Riunite di Fiammiferi, a match company that had owned the works at Pontenuovo di Magenta since 1898.

Saffa began to produce lighters in Pontenuovo in 1934, when it took over Uniat (Unione Nazionale Italiana Accenditori Torino), whose head office and factory were in Turin.

The factory at Pontenuovo, twenty-five kilometers from Milan, was the old Austrian customs house and the site of a famous battle fought on June 4, 1859, won by the French.

Saffa produced about thirty types of lighters. The earliest are names that reflect the years of Fascism: Aksum, Dux, Adua, and Impero. They resembled other lighters of the time, and the most valuable metal used was "800" silver. This alloy (80%) is harder that "925" silver, but tarnishes more quickly.

In 1959, Saffa brought out the Vulcano model, the first of its butane lighters. Its most handsome and original model was the Saffa 10, a butane lighter designed by Sartori in 1968.

Ronson — USA

Louis V. Aronson emigrated to the United States from Europe in the early years of the twentieth century, and founded the company Art Metal Work Inc. in Newark, New Jersey. His first lighter was the Banjo model, its name reflecting its unusual shape. Aronson registered many patents, the most important of which included the Touch Tip table model and the automatic lighting mechanism operated by vertical pressure. In the early 1950s the name of the company was changed

to Ronson Corporation. The firm also manufactured lighters in England, France, and Germany.

Zippo — USA

The Zippo Manufacturing Company was founded in 1932, in Bradford, Pennsylvania, by George G. Blaisdell. A partner in the Blaisdell Oil Company, he one day noticed a cheap Austrian lighter owned by a friend, and commented on its ugliness. The friend agreed, but pointed out that it worked well. Blaisdell decided to import lighters, with little commercial success. This led to the idea of designing and manufacturing a lighter that was both attractive and efficient. Production began in a room over an old garage. The result was named Zippo, the name deriving from the recently invented zipper. The model remained unchanged for half a century, except for the modification of the external hinge. In order the publicize his lighter, Blaisdell gave a number of them to a friend who worked in a bus station, asking him to distribute them to the long-distance bus drivers. During their journeys, passengers had ample time to see and appreciate the lighter. Blaisdell realized that a more conventional form of paid advertising would give quicker results, and he began selling lighters to small companies who gave them away to customers and employees. World War II saw his entire production absorbed by the armed forces.

George G. Blaisdell died in 1978, four years before the fiftieth anniversary of the Zippo lighter, which was celebrated with a special brass model.

BIBLIOGRAPHY

Bisoncini, S. *Lighters/Accendini*. Milan, Edizioni San Gottando, 1984.

Brandes, G. and Jarschel, R. *Feuer und Flamme*. Leipzig, Veb Fachbuchverlag, 1988.